THE HERALDIC ART OF JOHN FERGUSON

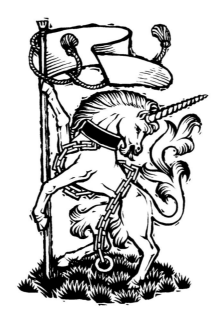

Edited by Stephen Friar

THE HERALDRY SOCIETY
2018
THE BOYDELL PRESS

First published 2018

A Heraldry Society publication
in association with The Boydell Press
an imprint of Boydell & Brewer Ltd
PO Box 9, Woodbridge, Suffolk IP12 3DF, UK
and of Boydell & Brewer Inc.
668 Mt Hope Avenue, Rochester, NY 14620–2731, USA
website: www.boydellandbrewer.com

ISBN 978-0-904858-05-1

A CIP catalogue record for this book is available
from the British Library

This publication is printed on acid-free paper
Design: Simon Loxley

CONTENTS

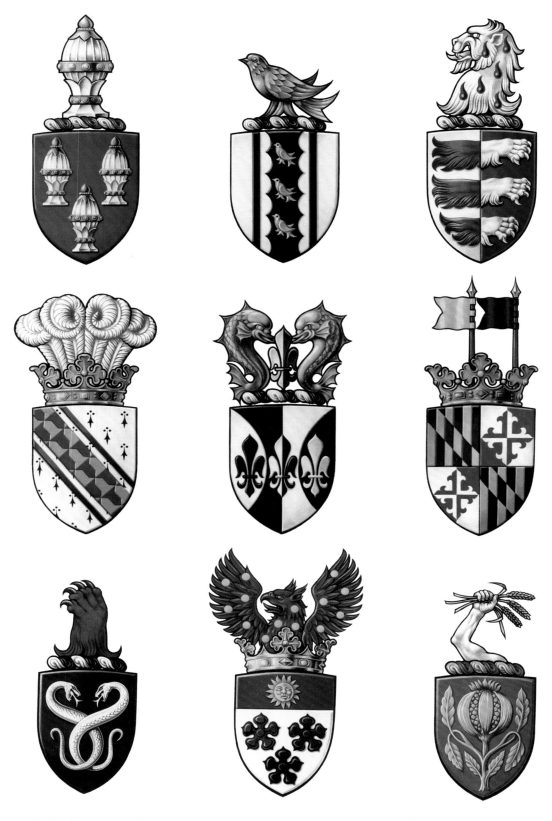

Crested shields of families descended from early settlers in America. Based on blazons in John Mathews' American Armoury and Blue Book *(1903, 1907, and 1911–23). Ayer, Wilkins, Wilson; Plumb, Robbins, Calvert; Nettleton, Stone, Granger.*

JOHN FERGUSON ARCA FHS FSHA DFACH FRSA

John Ferguson was born in Wimbledon, South London, in 1925. When at an early age he was told by a teacher that he would never make an artist, since he made such a mess of his exercise books, it only increased his desire to be one. Despite the teacher's presentiment, John later attended the Wimbledon School of Art where he studied graphic design. Here he came under the influence of a Miss Simeon, an inspiring lady who introduced him to the world of heraldry. The seed was sown, and a life-long love affair with this fascinating subject began.

In fact, this was only the first of two love affairs, both of which were destined to live side-by-side for the rest of John's working life. John met Barbara who was a student in the Illustration School and was immediately smitten. They were married in 1948, a union which lasted happily until Barbara's death in 2014, and are blessed with three daughters and a son.

At the age of a little over seventeen, John took the entrance examination for the Royal College of Art. He waited impatiently for the result which arrived a few weeks later – in the same post as his call-up papers for military service. The RCA would have to wait until the war was over.

His first heraldic commission was the painting of divisional emblems on the mudguards of eight Bedford trucks, the unit's transport vehicles. Being the Army, the 'commission' could not be refused and was unpaid. However, it did result in John's being excused pack-drill. Clearly, his superiors considered it safer to entrust him with a paint brush than a well-oiled Lee-Enfield .303 rifle.

After several weeks' training, John's regiment was drafted to India and from there to Burma with the Fourteenth Army. On arrival in Rangoon at the end of hostilities, John transferred to the

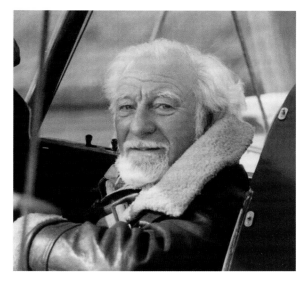

At Redhill aerodrome at a time when John was often engaged to take aerial photographs, though more often from a helicopter than from this splendid biplane. 'A view from above...' said John, '...much more fun than just stepping back from a drawing board – especially in a Tiger Moth on a bright sunny day.'

Army Education Corps. Here he helped establish a Forces art school in the damaged buildings of what had been Rangoon University.

On demobilisation, his studies were resumed at the Royal College of Art and John graduated in 1950. There followed nine years of graft at a West End advertising agency designing trademarks, corporate identity schemes, posters and exhibition stands. However, John's heraldic interests were still latent: whenever a request came into the studio which required a shield or a lion rampant the cry would go up '...give it to Fergie – he's good at that sort of thing!'

By 1959 John had had enough of the advertising rat race and left the agency to establish his own freelance practice as an heraldic artist. In 1961 he received an invitation to join the staff

Barbara Ferguson — when they met, John was 'immediately smitten'.

of the Guildford School of Art as a lecturer in graphic design. Shortly after his appointment, the Guildford and Farnham art schools amalgamated in the newly established West Surrey College of Art and Design where John became a Senior Lecturer. It was at this time that the opportunity arose for John to join Anthony Wood and Dan Escott to work on the heraldry and calligraphy course they had established at Reigate. John and Anthony were old friends and remain so to this day. Sadly, both have now been obliged to 'wash out their brushes' for the last time, due to old age and ill health.

As an established heraldic artist both in the UK and abroad, John has been producing fine heraldic artwork for private clients, corporate bodies, civic authorities and international companies for over sixty years. Commissions have ranged widely from library paintings for a resident of Christmas Island in the Pacific and another in Alaska, to the design of a set of immense engraved glass doors for a well-known public school, an emblem painted on the side of a space rocket and devices for a millionaire's private miniature railway. John has also been asked to draw an extraordinary collection of objects in the course of his heraldic art, including a New Jersey lobster buoy, an African mud crown, a narrow-gauge saddle-tank locomotive, and even a kitchen cranket (a medieval roasting spit – see page 15). As John says: 'Doing heraldry boring? I think not!'

An 'African mud crown'? Well, thereby hangs a tale...

The front door bell rang just before noon. Standing on the threshold were two tall, very distinguished, African gentlemen, attired in beautifully cut dark suits. One, carrying a black leather document case, smiled. 'I should like to talk with Mr John Ferguson concerning some heraldic work. We have seen his website and would like him to help us.'

When settled in John's lounge and having been introduced to Barbara, who was not a little cautious, the briefcase was opened and a wad of notes, photographs of various artefacts, weapons and plants, laid out on the table. Last to be removed from the case was a plain sealed envelope. 'Our king wishes us to obtain from you a design for a coat of arms for our Tribal Kingdom. Here, for your reference, are photographs and notes of the items of which the design must be composed. All the items must be included. In the envelope is sterling currency to cover the cost of the work. If the amount is insufficient please let us know. We would like to receive the finished design within one month and we will collect the work when it is ready.'

Barbara produced coffee, they chatted for a while and then the two delightful gentlemen prepared to leave. On their departure they shook hands with John, bowed and took Barbara's hand and formally kissed it.

Barbara, visibly shaken by this display of old-world gallantry, gave John a bemused look and observed that he had never wished her goodbye so elegantly, adding 'You'd better get started then: you've only got a month and you've already been paid!' Barbara could be very blunt at times ...

Fast-forward to the job itself: the items to be included in the design were a ceremonial drum, two ceremonial knives, a pair of carved elephant tusks, palm fronds, a round shield bearing specified tribal devices, a form of metal cattle bell, two leopard supporters and, yes, a mud crown – made especially to photograph for the occasion. Details

of all these elements were included in the wad of photographs as well as notes together with details of their significance. As John admits 'Rarely have I received such a thorough briefing – and been paid generously, it must be said, up front!'

He completed the task in two weeks. It was collected, again with great courtesy and embarrassing appreciation, by the same two elegant African gentlemen. Farewells were said with the same old-world formality and the front gate of number 46 closed behind them. John has heard nothing further from them. It was as if it never happened – but it did, and here is John's painting to prove it...

For John, Heraldry has opened many doors, demanding of him all his imagination and undoubted ability as a draughtsman and graphic designer. It has required him to experiment with giving two-dimensional colour a deeper dimension, enabling it to glow like enamel. Above all, it has instilled in him a love of and respect for fine craftsmanship, he has relished the day-to-day challenge of heraldic design and is constantly inspired by the example of others.

John Ferguson is now recognised as pre-eminent among the heraldic artists of his generation. Among his many achievements, he has been elected a Fellow of the Society of Heraldic Arts, a Fellow of the Heraldry Society and a Distinguished

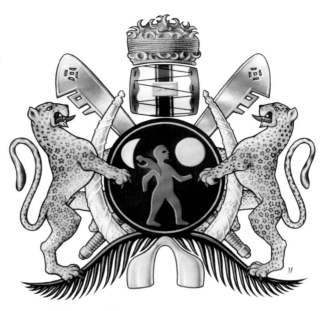

Arms of African Tribal Kingdom.

Fellow of the American College of Heraldry. He was among the small band of enthusiasts who met at my home in Dorset in 1987 and founded the Society of Heraldic Arts which today is established as a highly respected international guild of heraldic artists, designers and craftspeople.

This book not only celebrates John Ferguson's pre-eminence as an artist, it also proclaims his generosity of spirit which has been an inspiration to us all. And it is for this reason that his friends and colleagues at the Society of Heraldic Arts determined to create an enduring record of his artistic achievements in this book.

Stephen Friar M.Phil FHS FSHA

JOHN FERGUSON'S METHODOLOGY

Preparing and finalising the design of an heraldic painting

Drawing the elements which make up a coat of arms – the shield with its various charges, the helm and mantling, supporters and motto scroll – all require drawing and re-drawing until the images are fine-tuned to satisfaction. To achieve this without spoiling the artwork surface is essential. This is best done using several sheets of thin layout paper – sufficiently thin to see through. Then, by working one drawing over the previous one, a final refined and satisfactory image can be arrived at. With this definitive drawing the image can be transferred onto the artwork surface ready for painting.

Next, the offset sheet is prepared using the same thin paper as that used for the preceding drawings by coating it with very soft graphite dust. Use the lead from a 3B or 4B pencil ground to a powder and applied to the paper with a knob of cotton wool. When evenly applied dust off any surplus powder. You now have, in effect, a form of 'carbon paper'.

Placing the finalised drawing on the artwork surface by fixing along the top edge so that it can be lifted while tracing to check that nothing has been missed, insert the pencil lead offset sheet beneath the drawing and trace the image through onto the artwork surface. For tracing down the image use a sharp hard pencil (3H) and do not press too hard when tracing. All is now ready for painting. When completed, any visible traced lines can easily be removed with a putty rubber. One final thought: never use a real carbon paper – it is greasy and cannot be removed with any form of eraser.

Paper Stretching

In order to prevent cockling (planar distortion) when using water or gouache colours, and to improve the working surface of the paper, it is advisable to stretch the paper by soaking and then drying out the sheet, thereby shrinking it. This produces a taut, drum-like surface, grease-free and delightfully smooth to work on.

The method is simple: immerse the paper in clean warm water. When soaked, lay the paper onto a drawing board and blot or sponge off all surplus water. Then paste down all round the edges using brown sticky paper tape. Gently blot or sponge once more before standing the board upright to dry off. If tempted to enhance the drying by using a hair-dryer be careful not to be impatient – prolonged application of heat will cause the paper to shrink drastically and will result in the splitting or lifting of the brown paper which is securing the paper at its outer edges.

Choice of brushes

Pure red sable brushes are by far the best, having a good spring in them and retaining a sharp point. They also retain moisture well when working. The most useful sizes are 0 through to 3 for detailed working and 4 to 6 for broad flat areas. The fine brush sizes are ideal for drawing in the shaded areas in much the same way that one would shade with a pencil. Never leave paint on brushes but always wash them out thoroughly when work finishes, otherwise brushes will lose their spring and become useless.

Gouache colour: what is it?

Simply, gouache colour is an opaque water colour, whereas true water colour paint is transparent and applied in wash form. Clearly, gouache colour is best suited to the work of heraldic painters where the use of bold and brilliant tinctures is required.

There is an extraordinary range of colours available in gouache paint, most of which are quite unnecessary. Always take great care to use colours which are light-fast. All the most reliable colour manufacturers provide colour charts which indicate the degree of permanence and the choice should be made accordingly. When, as in the case of a presentation painting, the work is to be framed and glazed, it is advisable to specify ultra-violet safety glass. This will afford protection against sunlight fading out the colours should the client be foolish enough to hang the painting on a sunny wall!

A great tip when using gouache colour is to use old 35mm film pots for mixing colours. These have usefully airtight caps which enable one to keep colours moist when not in use. Zinc White is best for mixing with other colours. This pigment, when mixed, causes less deadening of the prime colour when used to lighten the tone. Where a full brilliant white is required, Permanent White is recommended. My choice of manufacturers of gouache colour are Winsor & Newton and Schmincke Horadam colour.

Colour gradation

When giving form to the surface of three-dimensional objects such as helmets, mantling, etc., the laying down of the basic colour – for example, mid-grey for helmets – is the first step. Then, using a fine sable brush (size 1 or 2) with a good point and a consistency of colour which is not too runny, use the brush as one would a sharpened pencil. Draw rather than paint with the brush. Employ progressively darker shades of colour to build up the tone of the subject. Be careful to regulate and use to advantage the moisture of the colour as this is a valuable aid to the blending of tones. The light side of the subject, culminating in highlights when painting helmets, is achieved in the same way and this technique applies also to the treatment of gold objects, using a range of yellows and ochres.

John Ferguson

Distinctive German personal arms. These paintings, all in gouache colour and originally on hand-made paper, are four of a series of library paintings produced in 2004. The 'horns' in the crest of Schwanmger, though very rarely found in British armory, are relatively common in the heraldry of other Germanic countries (*see also* page 19). They have been blazoned 'Buffalo Horns' by various authorities, including A.C. Fox-Davies in *The Art of Heraldry* (London, 1904).

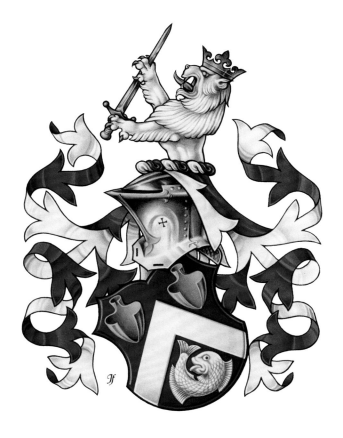

KUHNL

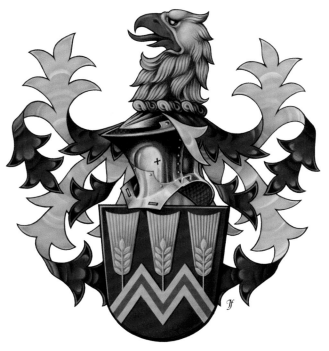

MATYSEK

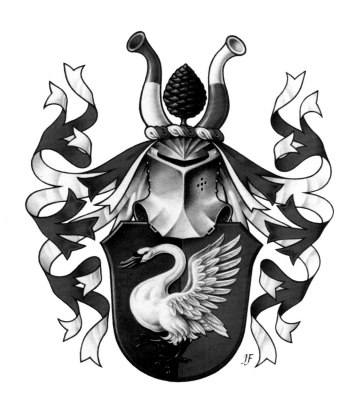

SCHWANINGER

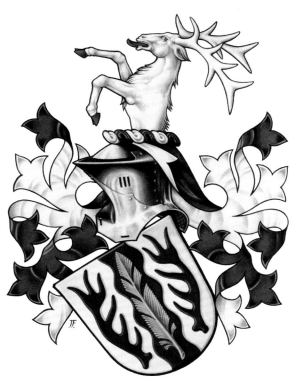

OBERTREIS

Personal arms: the armorial bearings of Langman, English nineteenth century. A demonstration painting prepared during an exhibition of heraldic art at Reigate Priory Museum, Surrey in 1998. Gouache colour on vellum.

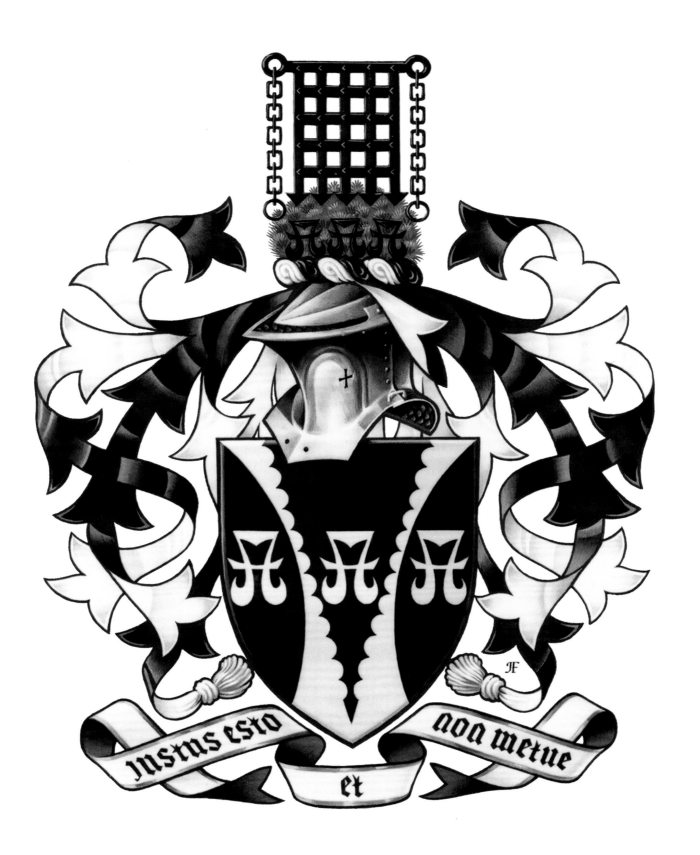

Justus esto et non metue

Heraldic badges worn by armed retinues and retainers in the Wars of the Roses, illustration from *Basic Heraldry* by Stephen Friar and John Ferguson (The Herbert Press, 1993). 1: Falcon and fetterlock badge of Richard Plantagenet, Duke of York. 2: De Vere cranket badge. 3: Black bull's head of Hastings. 4: Sir Walter de Hungerford's sickle and garb device. 5: Drag badge of the Lord Stourton. 6: Mill sail device of the Lords Willoughby. 7: De Vere's bottle with a blue cord.

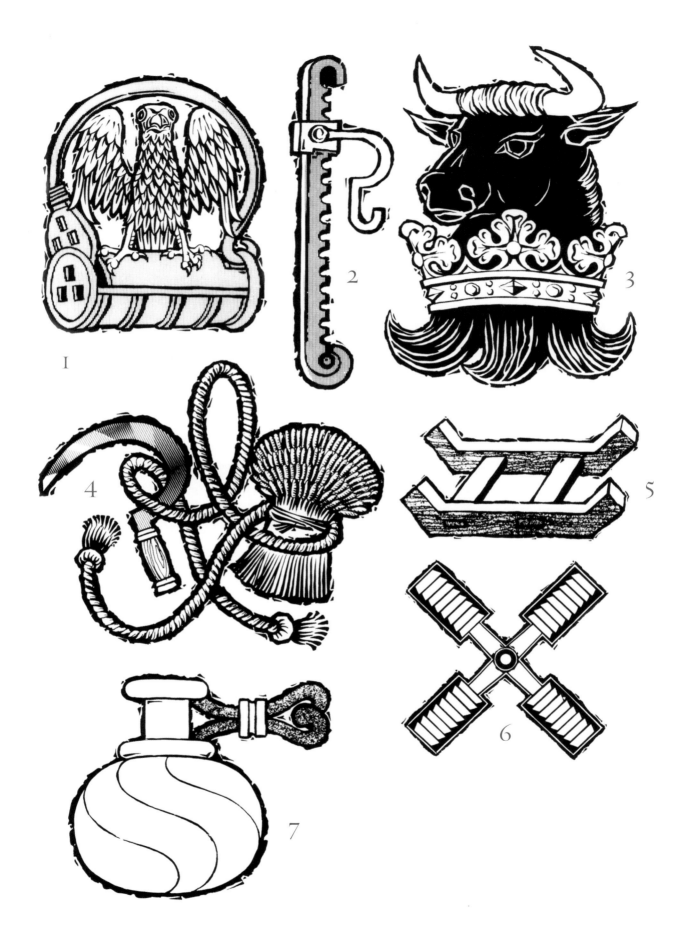

1

2

3

4

5

6

7

Personal arms of William MacDonald Bird, Esq. This library painting, which also incorporates the armiger's banner, is in gouache colour on hand-made paper.

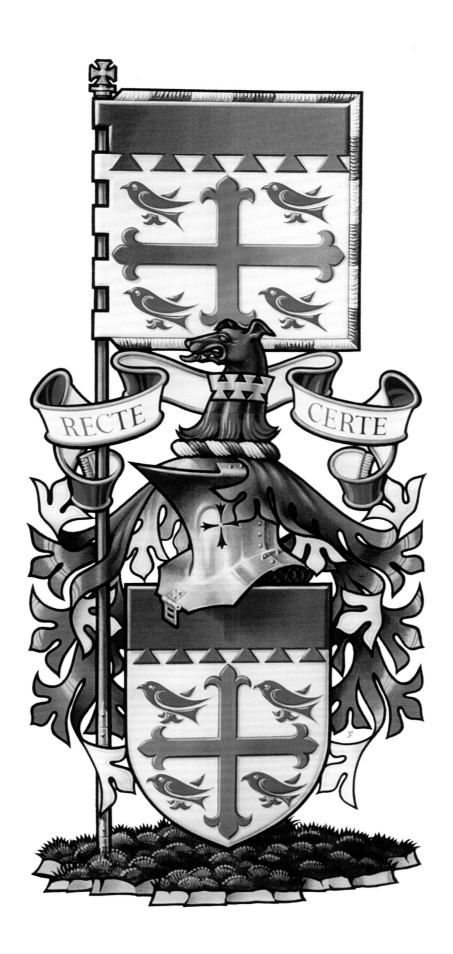

The armorial bearings of Danish heraldic artist Ronny Andersen, FSHA. Painted by John Ferguson without Ronny's knowledge, as a friendly and sincere fraternal acknowledgement from one heraldic artist to another. Both are Fellows of the Society of Heraldic Arts. Gouache colour on hand-made paper.

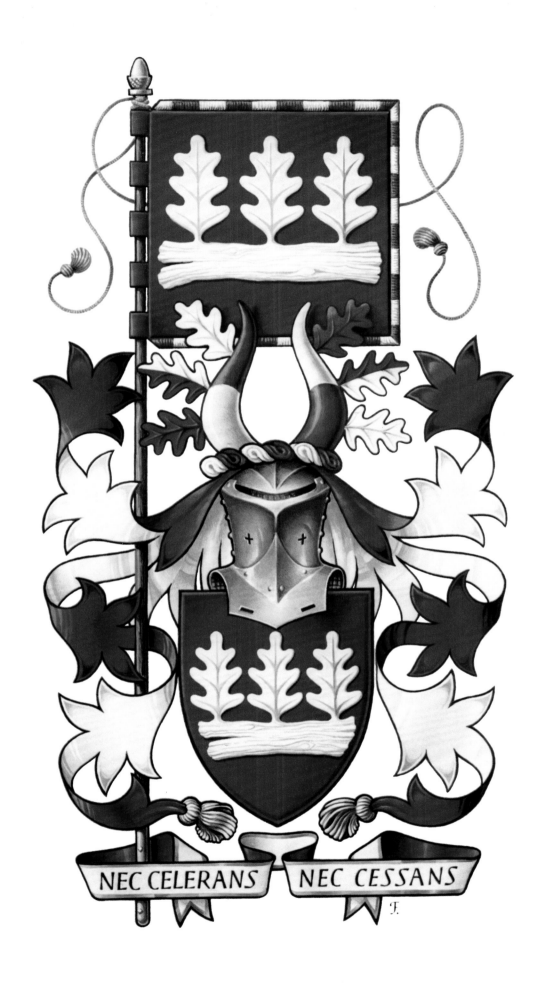

NEC CELERANS NEC CESSANS

The arms of the Levien family. The family is of European origin, the arms being granted to descendants in England in 1796. Library painting in gouache on hand-made paper, 2001.

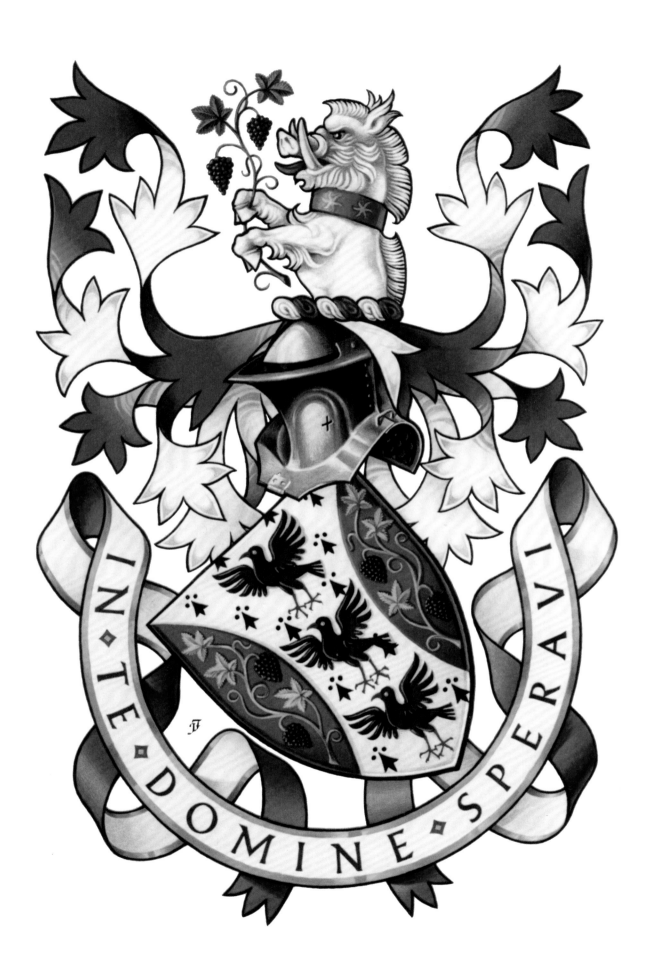

IN·TE·DOMINE·SPERAVI

Funeral hatchment. This work was designed and painted for the funeral of Richard Crossett of Louisville, Kentucky, USA. During a long career as an heraldic artist, Richard was responsible for much of the American military heraldry used today by various branches of the US forces. He was a close friend of the Ferguson family and visited John's home and studio. A member of the American College of Heraldry, Richard was one of the first overseas artists to become a Craft Member of the Society of Heraldic Arts.

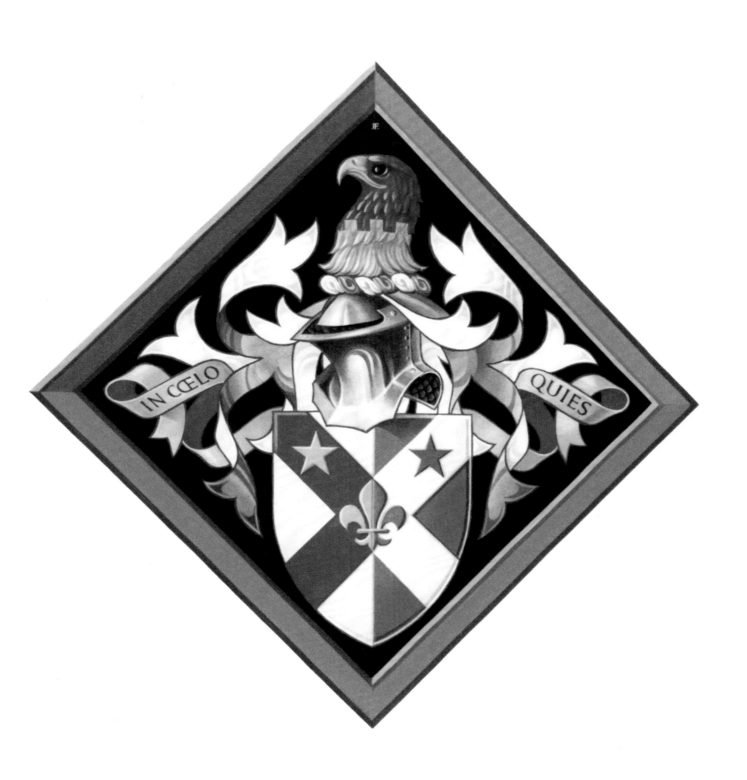

Municipal heraldry: the armorial bearings of the County Borough of Teesside. This work is one of a series of paintings in gouache colour on artboard forming a set of exhibition panels. The arms, together with a badge (depicted beneath the inscription) were granted in 1968. The artwork was painted in 1976.

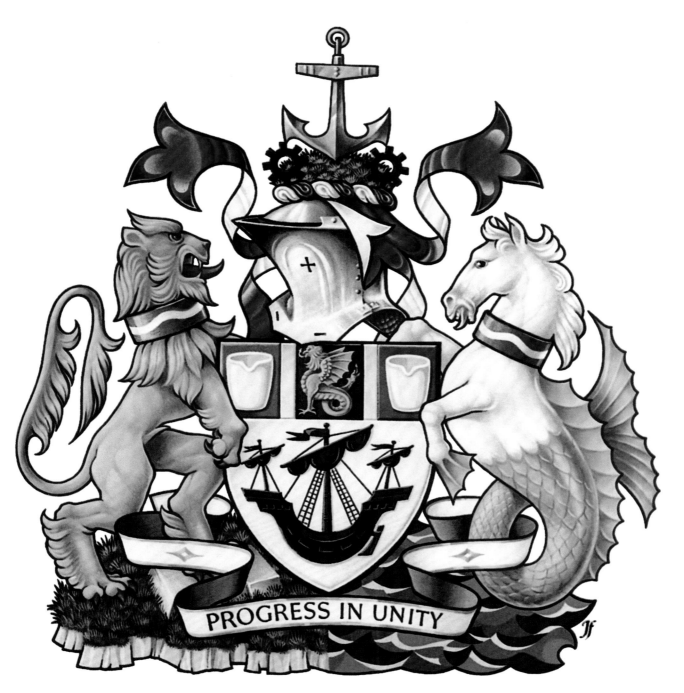

COUNTY BOROUGH OF TEESSIDE

The arms of Reginald Charles Edward Abbot, third and last Baron Colchester. The barony became extinct in 1919. The composition, which includes arms, crest, unicorn supporter and banner, was designed for the jacket of *Basic Heraldry* which was written by Stephen Friar, illustrated by John Ferguson, and first published by The Herbert Press in 1993.

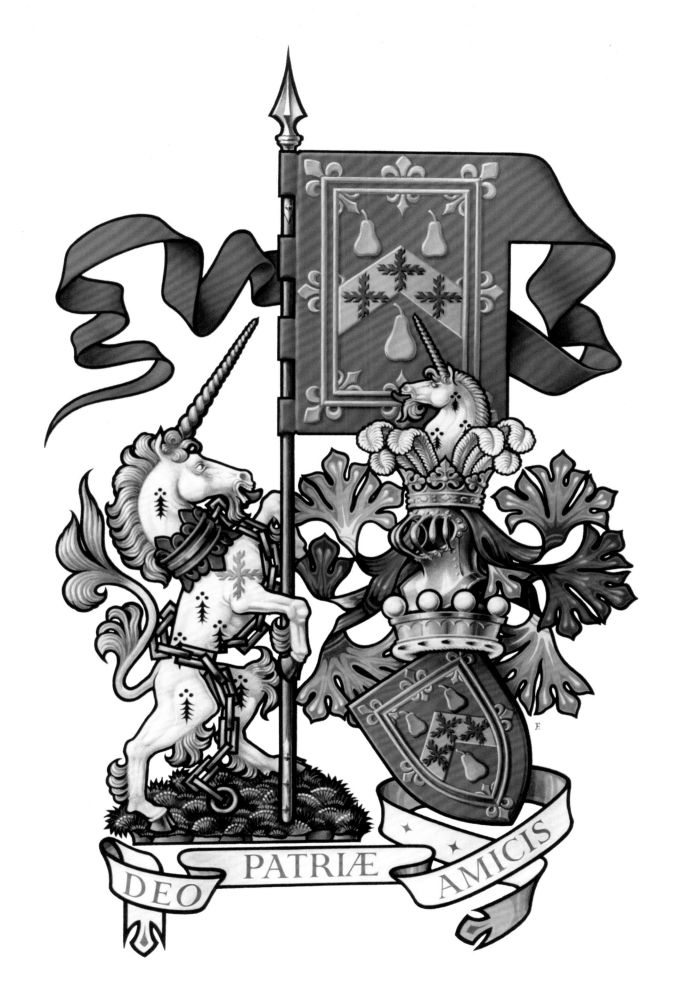

DEO PATRIÆ AMICIS

The arms of a maiden lady incorporating the impaled arms of her mother and father. Her parents' crests are depicted in the corners of the frame above the elaborate lozenge-shaped shield. While produced primarily as a library painting in 2004, the work was also reproduced as a full-colour bookplate.

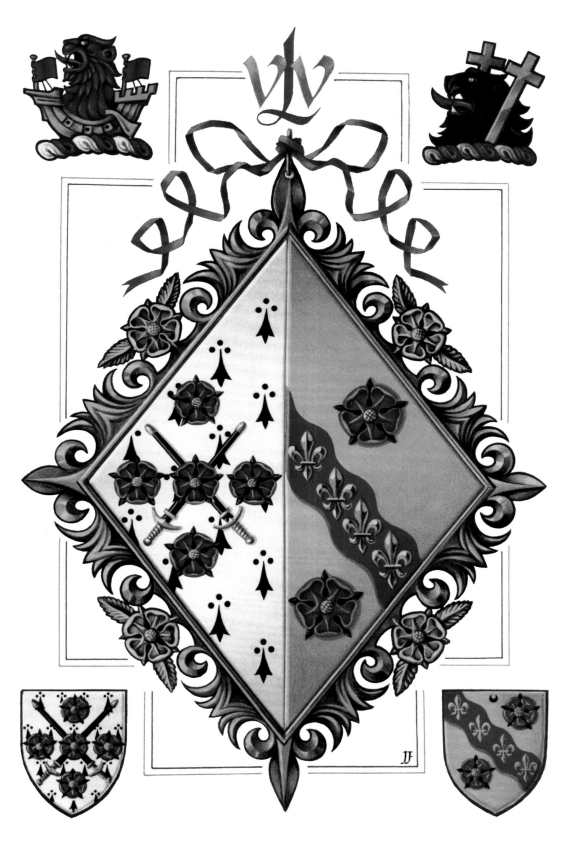

VICTORIA · LEONE · VENEDIGER

The arms of Jack Carter, Esq., USA. A library painting in gouache colour on vellum, commissioned in 1986.

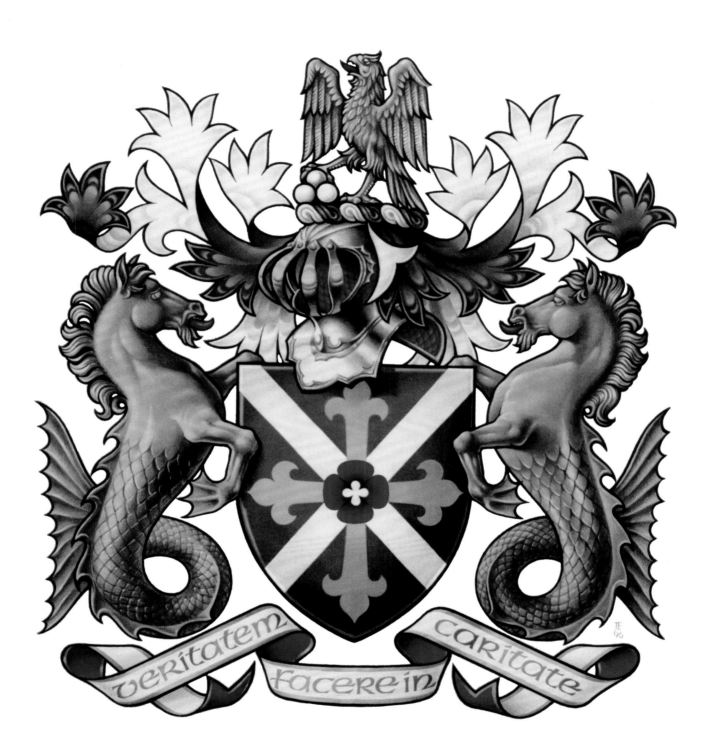

veritatem facere in caritate

Historic heraldry: a reconstruction of the effigial figure of an unknown knight commemorated in Canterbury Cathedral, Kent. The existing effigy has been worn down over the years and virtually all details of costume and colour are now gone. This painting, together with four others, was an attempt to reconstruct the effigies as they might have looked when freshly painted, using heraldic details gleaned from bosses in the vault of the Cathedral's great cloister. This set of artwork was prepared especially for the Heraldry Society's exhibition at the Victoria and Albert Museum, London, in 1981. Executed in gouache colour on artboard.

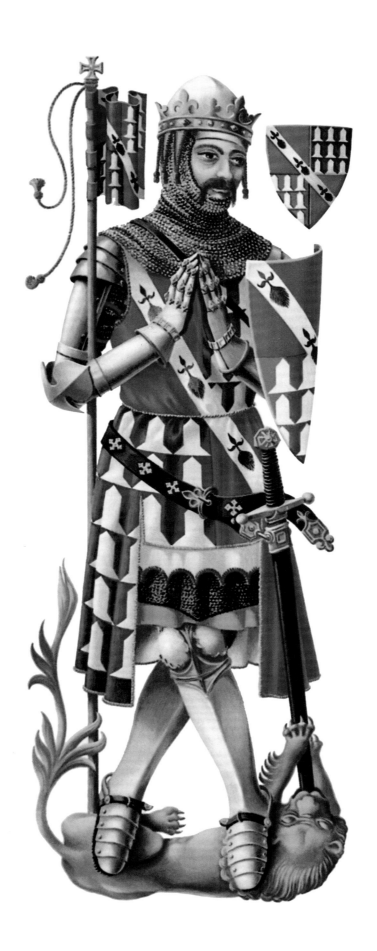

The arms and banner of John Reginald Marriott impaling Rostron. A painting in gouache colour on hand-made paper, 1969.

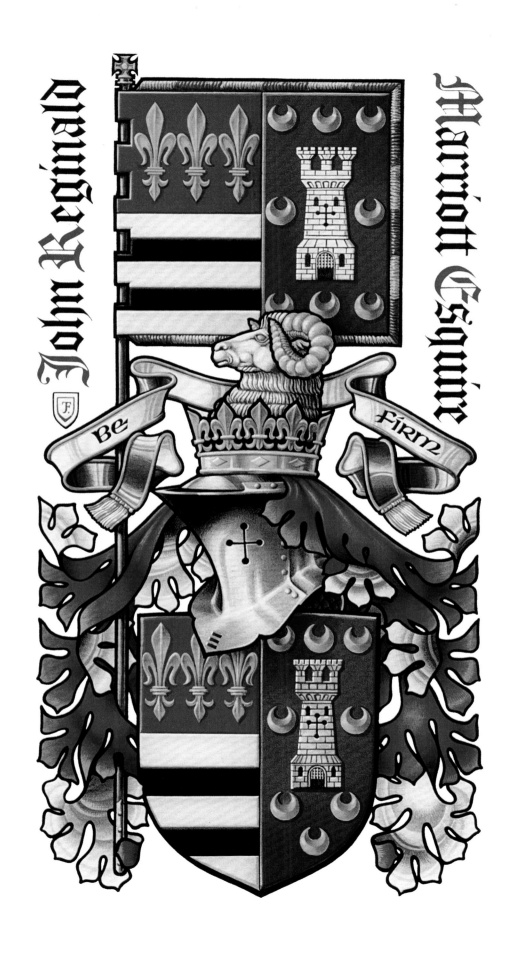

John Reginald

Marriott Esquire

Be Firm

Municipal heraldry: the arms of the former Luton District Council, Bedfordshire. A painting in the form of an heraldic roundel. One of a series of similar works in gouache colour on display board used in this form for exhibition purposes in 2002. The arms were granted in 1959.

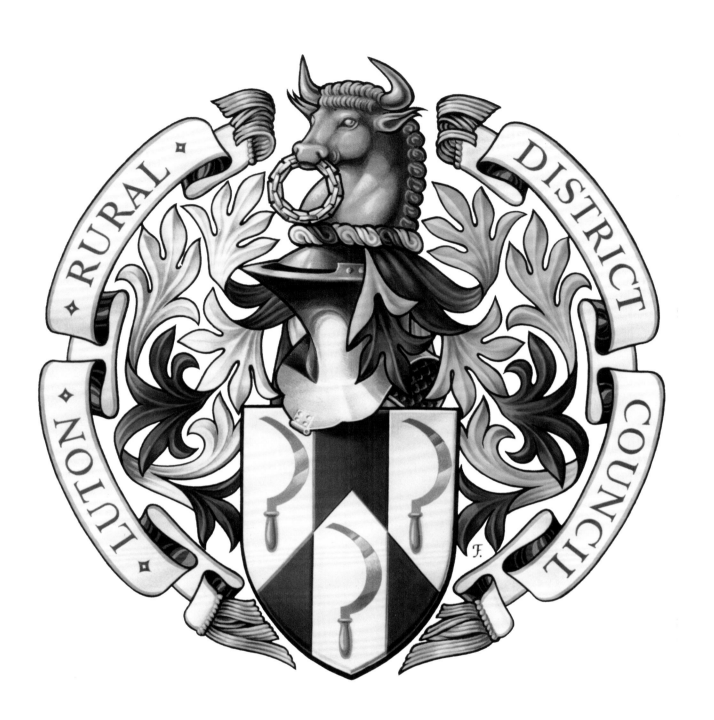

Historic heraldry: the arms of Sir Guy de Bryen (sometimes de Bryan), first Baron Bryen, admitted a Knight of the Garter in 1370, died 1390. One of six paintings of the arms of Garter knights prepared for an exhibition in 2003.

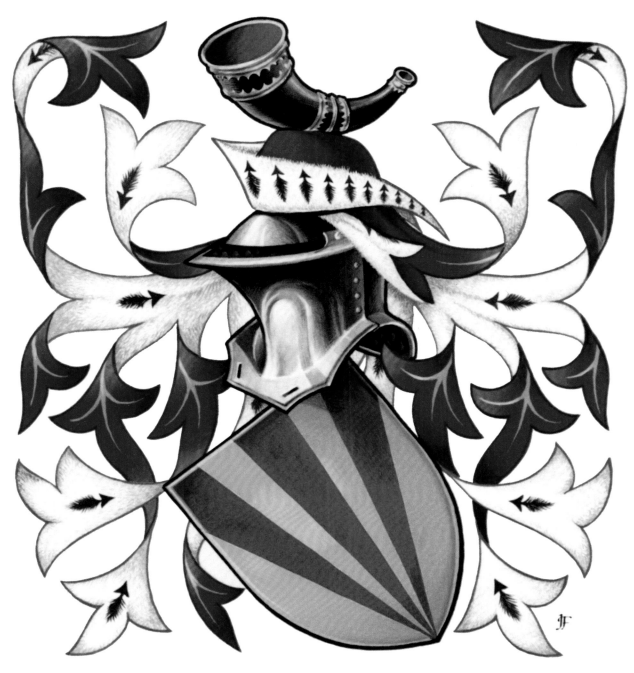

SIR GUY DE BRYEN
GARTER✝KNIGHT
1370 ⚓ 1390

Library painting in gouache colour on vellum depicting the arms of Faulkner, *c.* 1968.

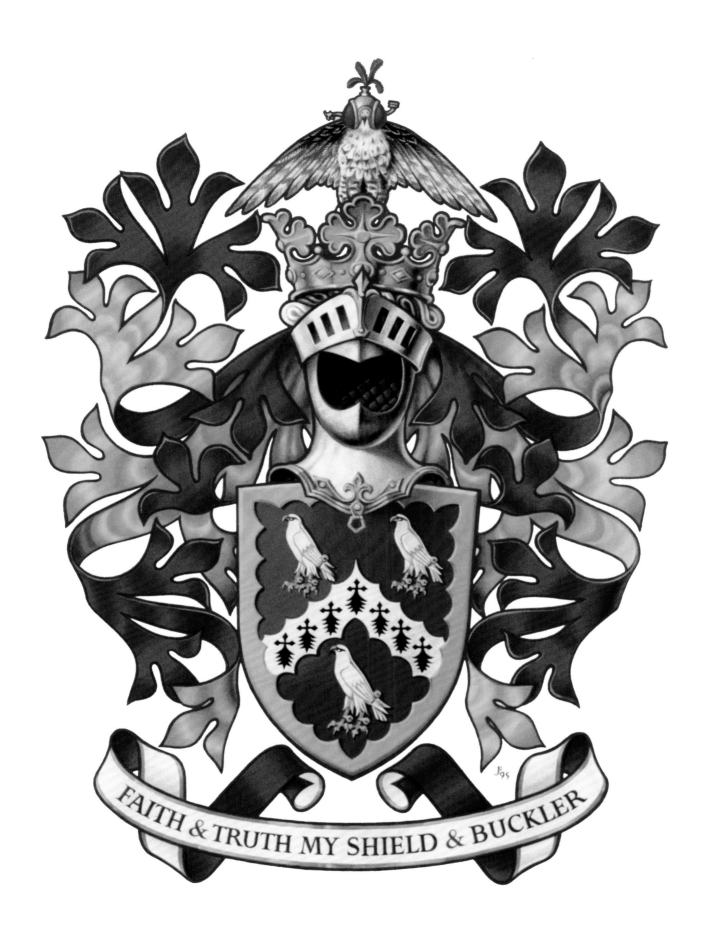

FAITH & TRUTH MY SHIELD & BUCKLER

The armorial bearings of Dr Royce Lynn Money, USA. A library painting in gouache on hand-made paper, 2002. The charge in the base of the shield and also forming the crest is known as a spade iron, a type of reinforcement attached to the blade of a spade, the shape of which lends itself perfectly to the outline of the shield.

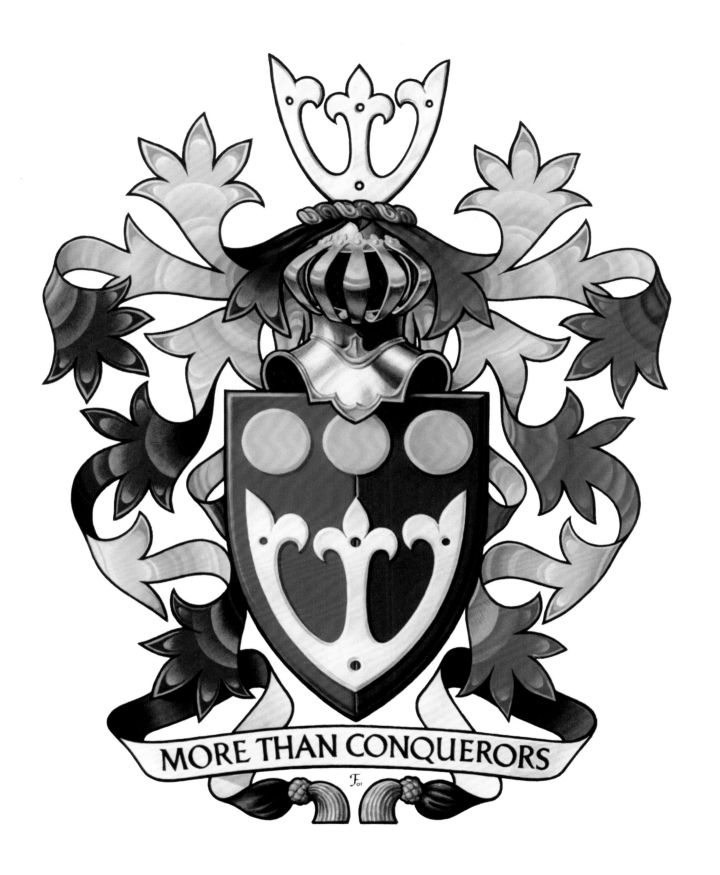

MORE THAN CONQUERORS

Historic heraldry: a design for a memorial tablet featuring the arms of Edmund Uvedale who died in 1606. Gouache colour on artboard, 1973.

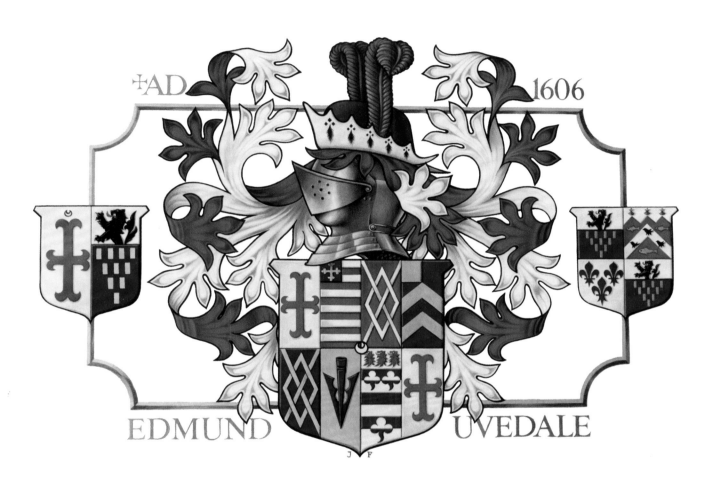

✝AD 1606

EDMUND UVEDALE

Municipal heraldry: the arms of the former West Penwith Rural District Council, Cornwall (abolished in 1974). The arms were granted in 1953. Painted in the form of a roundel in gouache colour on board, the work was used for exhibition purposes in 2002.

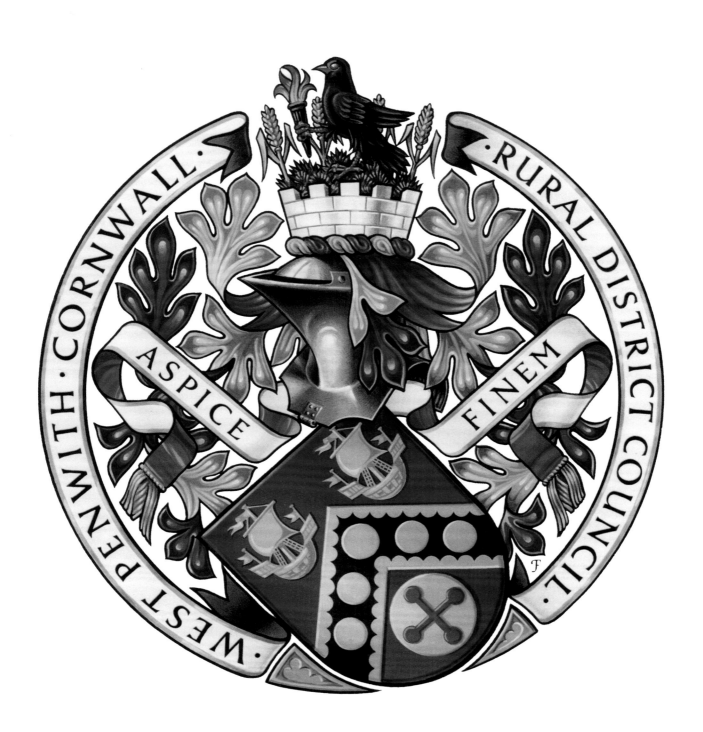

WEST PENWITH · CORNWALL · RURAL DISTRICT COUNCIL ·

ASPICE FINEM

Corporate heraldry: (*top*) the full achievement of arms of the University of Southern Utah, USA. These arms were redesigned for the University in 1995. Individual shields of arms were also designed at this time for each of the four University faculties. In addition to the paintings illustrated here, other artwork was produced for reproduction in both colour and black and white for a variety of applications: seals, stationery, blazer badges, flags etc., all had to be included in what amounted to a comprehensive scheme of corporate identity. The University's seal (*below*) was reproduced in colour for use in print form, and in black and white for the manufacture of a conventional seal. The arms were duly registered with the American College of Heraldry despite the University's design infringing the first rule of armory (the tincture convention) in the second and third quarters – 'Metal (gold or silver) shall not lie on metal, nor colour on colour'.

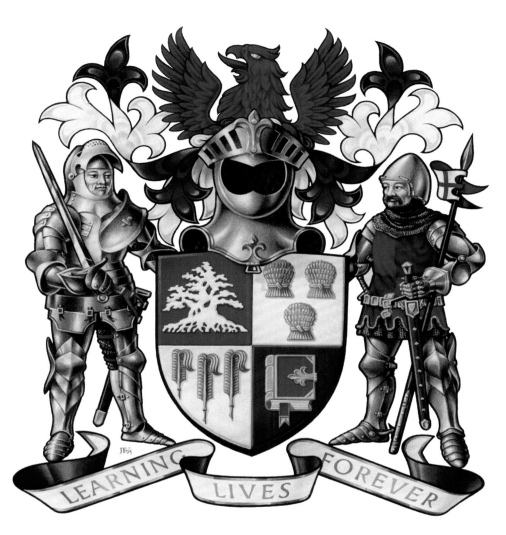

LEARNING LIVES FOREVER

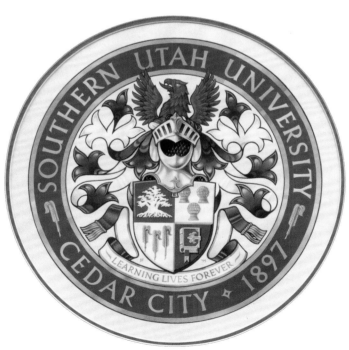

Effigial figures: conjectural designs based on heraldry in the late fourteenth-century cloister vault of Canterbury Cathedral. An illustration from *Basic Heraldry* by Stephen Friar and John Ferguson (The Herbert Press, 1993). One of a display of artwork prepared especially for the Heraldry Society's exhibition at the Victoria and Albert Museum, London, in 1981 *(see also* page 25). Executed in gouache colour on artboard.

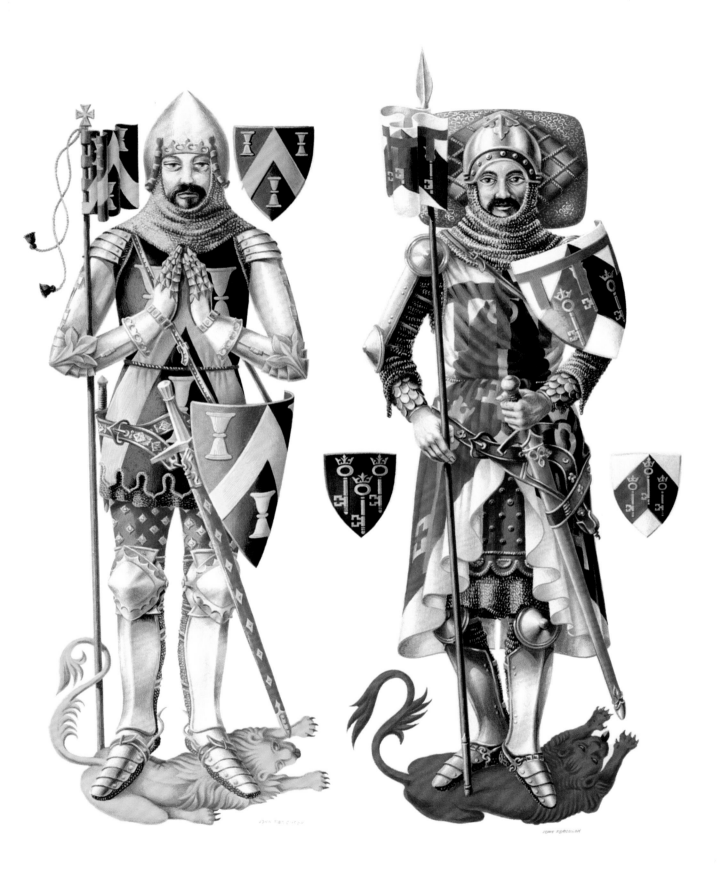

A reconstruction of the ancient arms of the Herbst family. Painted in 1994 in gouache on a vellum textured paper, this artwork remains in the possession of the artist.

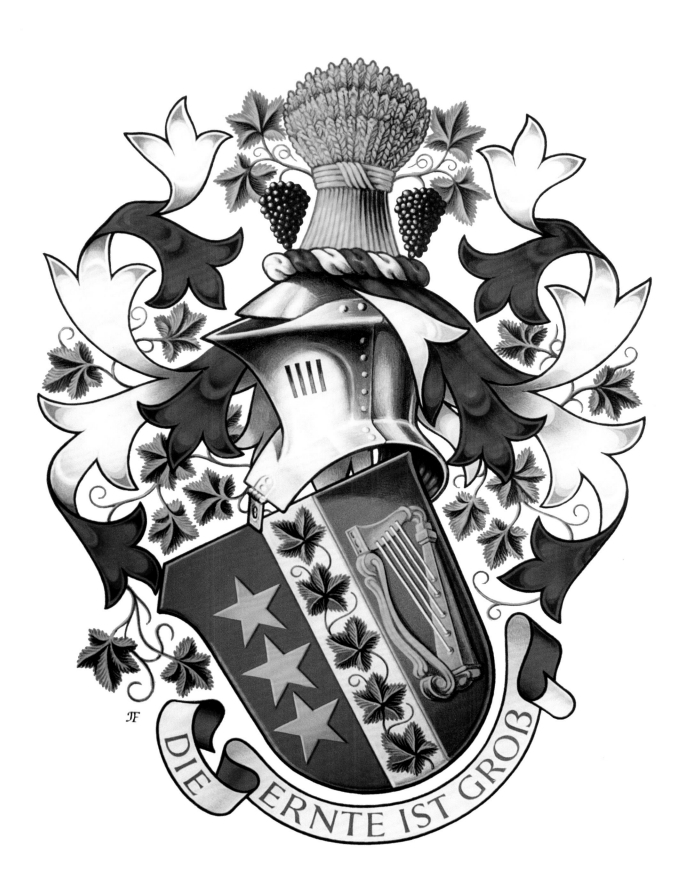

DIE ERNTE IST GROß

A gouache colour painting of the armorial bearings and badge of the Honourable John Michael Johnson, JD. Commissioned as a library painting, a black and white line version was also produced for print use.

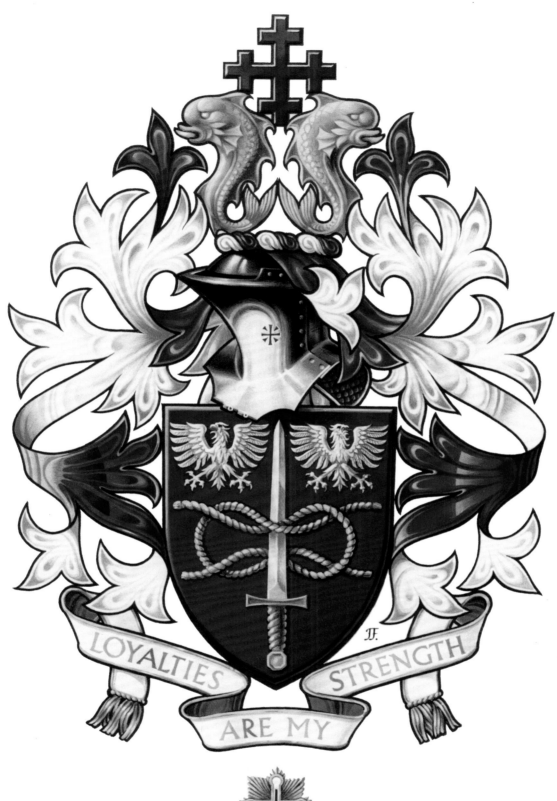

LOYALTIES STRENGTH ARE MY

The Honourable
John Michael Johnson

A gouache colour painting of the arms of the Saunderson family. The design was developed from the blazon (heraldic description) found in *Armorial Families* by Arthur Fox-Davies. The work is in the possession of the artist.

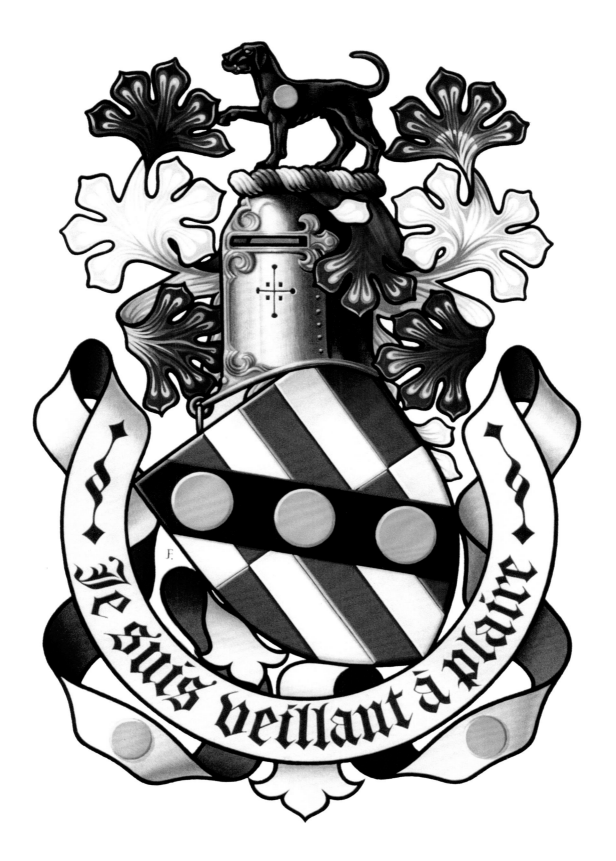

Saunderson

The arms of Richard Berridge, Esq. Library painting in gouache on vellum, 2001.

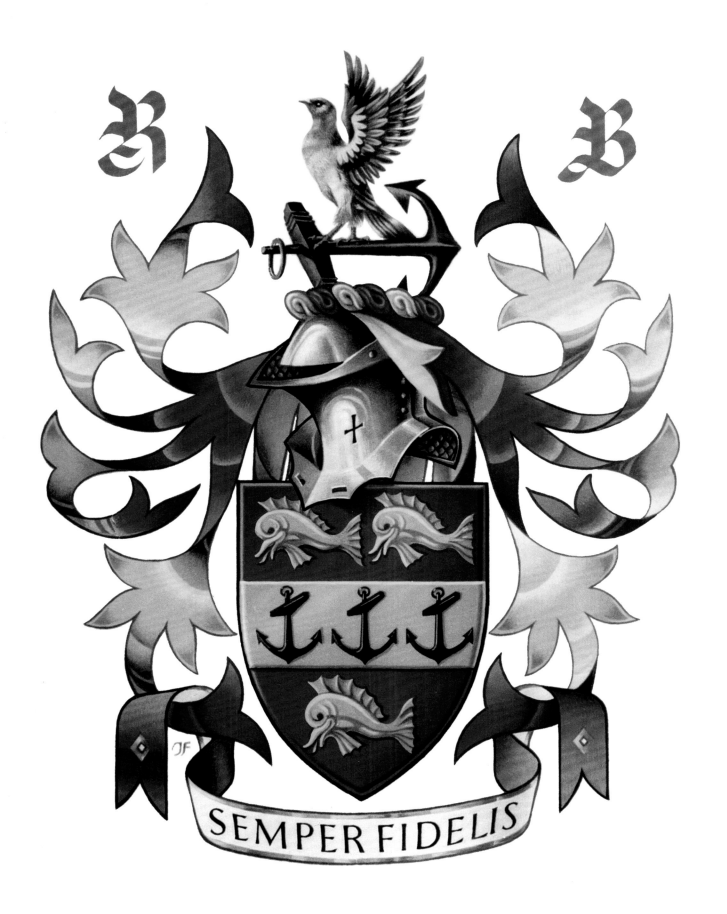

SEMPER FIDELIS

An exhibition painting in gouache of the armorial bearings of James Wallace Paten, Esq., of Birkdale, *c.*1970.

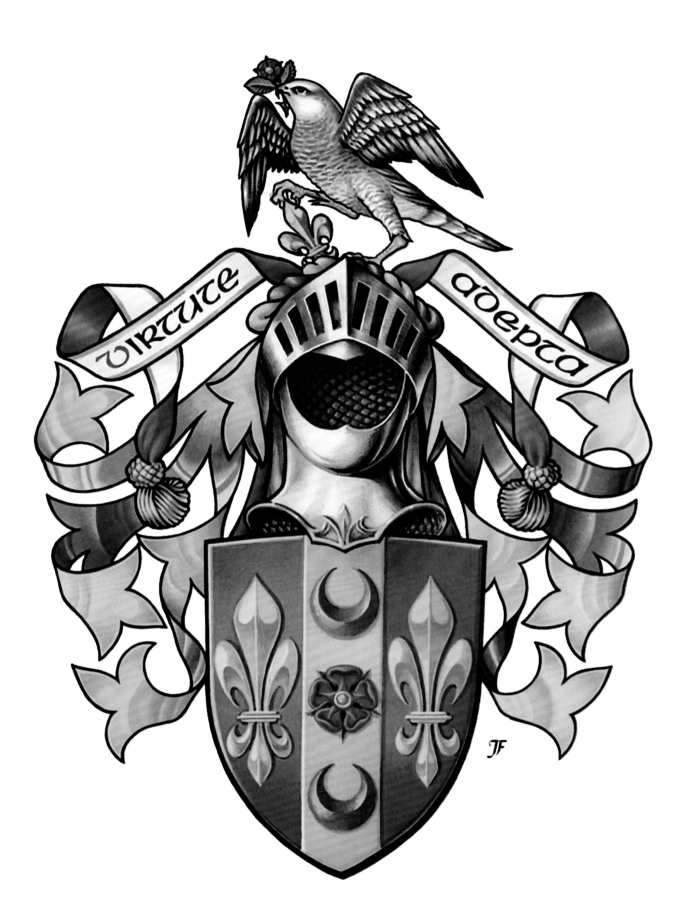

The arms of George Bidie, Esq., Surgeon General in the Indian Medical Service in the 1920s. As is the usual practice in Scottish heraldry, the motto scroll is depicted above the crest. The extensive use of purpure (purple) is both an attractive and relatively unusual tincture in heraldry. The work was commissioned for illustrative purposes in 1989.

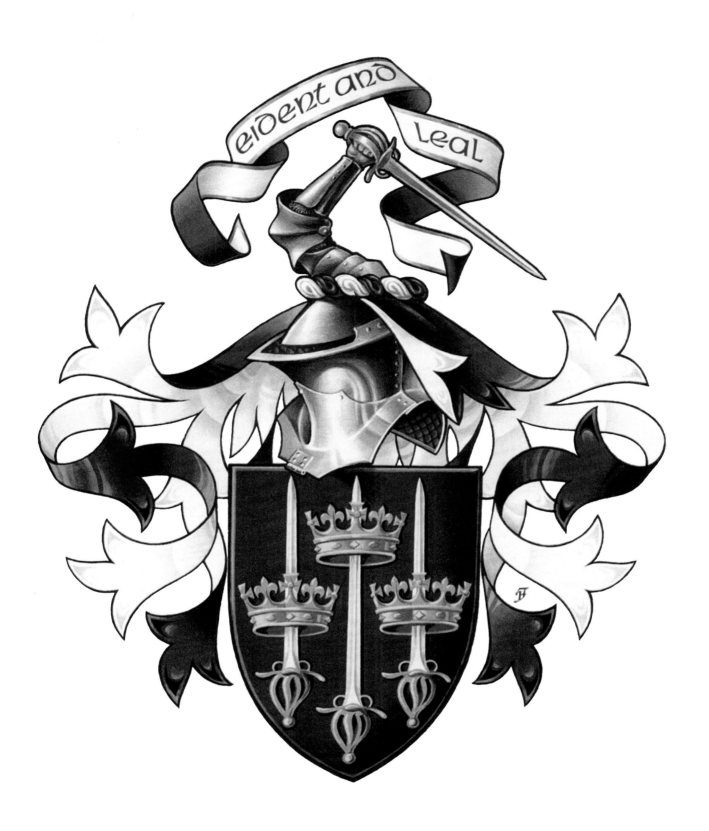

The armorial bearings of Baron Desborough of Taplow, Buckinghamshire. The peerage was created in 1905 but became extinct in 1945. The painting was produce in gouache on artboard for exhibition display in 1975.

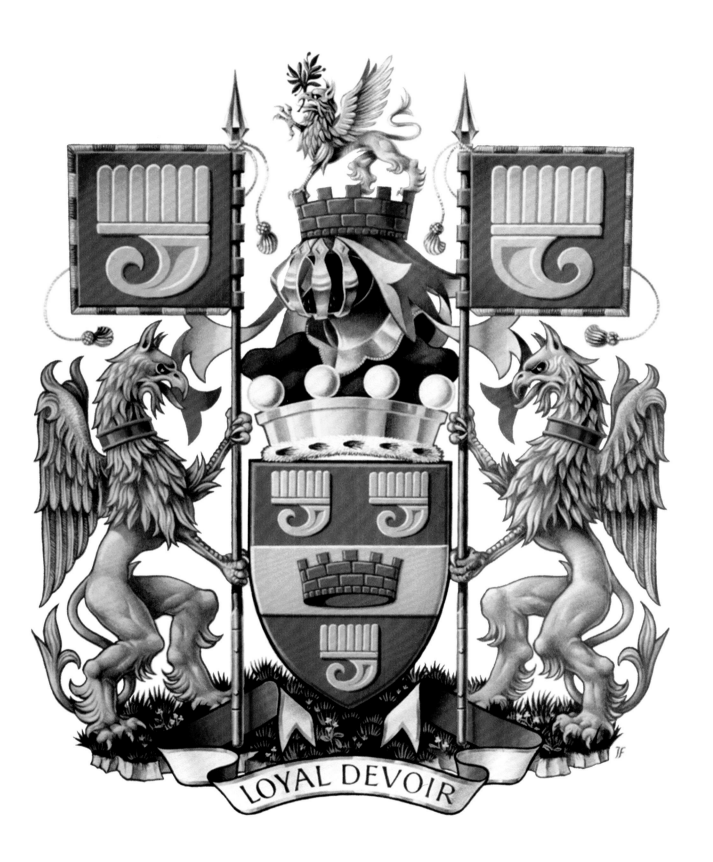

LOYAL DEVOIR

The arms of Alpheus Todd, CMG, LL.D, of Canada. Born in London, England in 1821, he died in Ottawa in 1884. His wife's arms are displayed on an inescutcheon at the centre of his shield. This painting was made for a projected memorial document and is on vellum-finished paper in gouache colour.

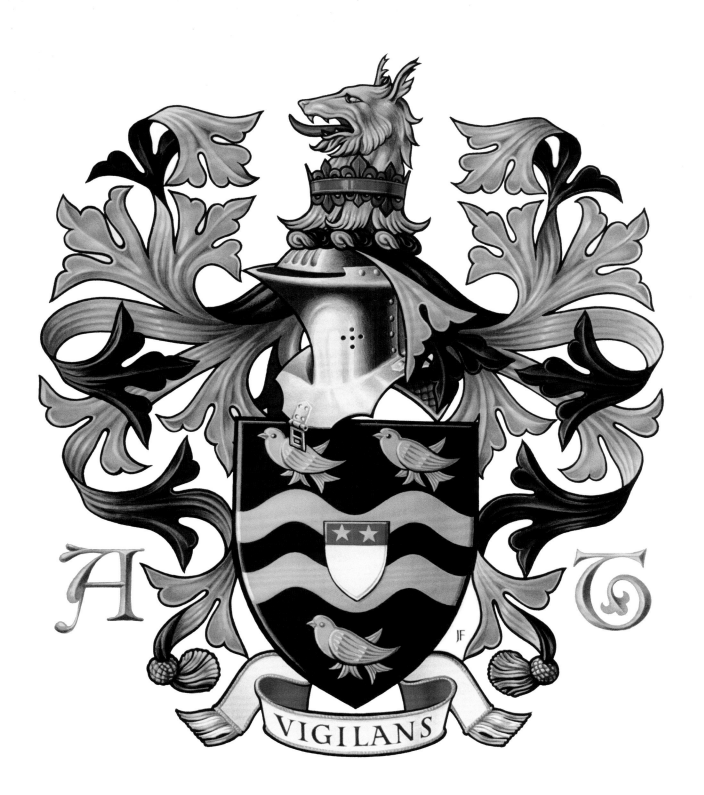

VIGILANS

Municipal heraldry: the armorial bearings of Abingdon, Oxfordshire, England. Arms were entered at the Visitations of 1566, 1623 and 1666. Crest and supporters were granted in 1962. This painting is one of a series of eight municipal arms prepared for a display in 1971. Gouache on art-surface display board.

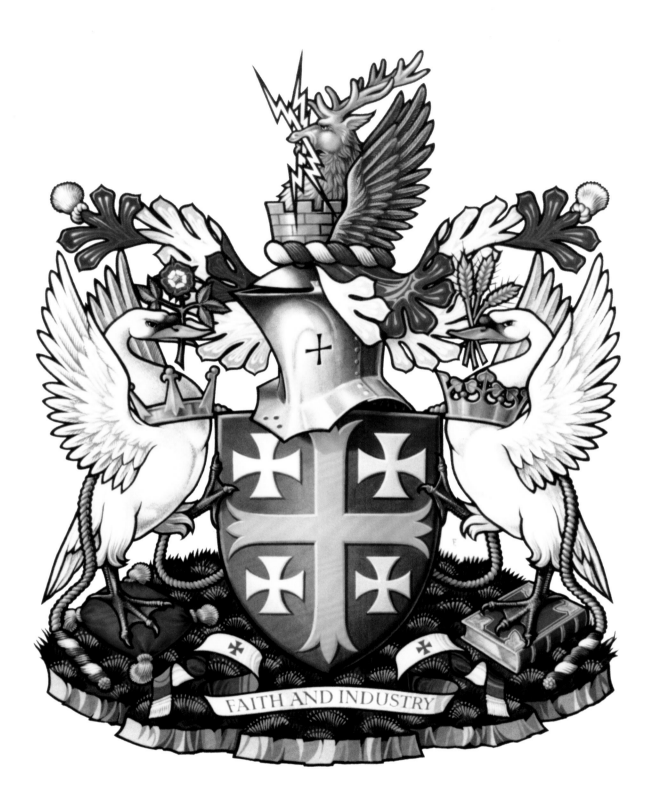

FAITH AND INDUSTRY

ABINGDON

Another in the series of municipal arms painted in 1971. These are the arms of Calne in Wiltshire, England. Again, they are an early example of municipal armory, having been recorded at the Visitation of 1565. The crest and supporters were granted in 1950.

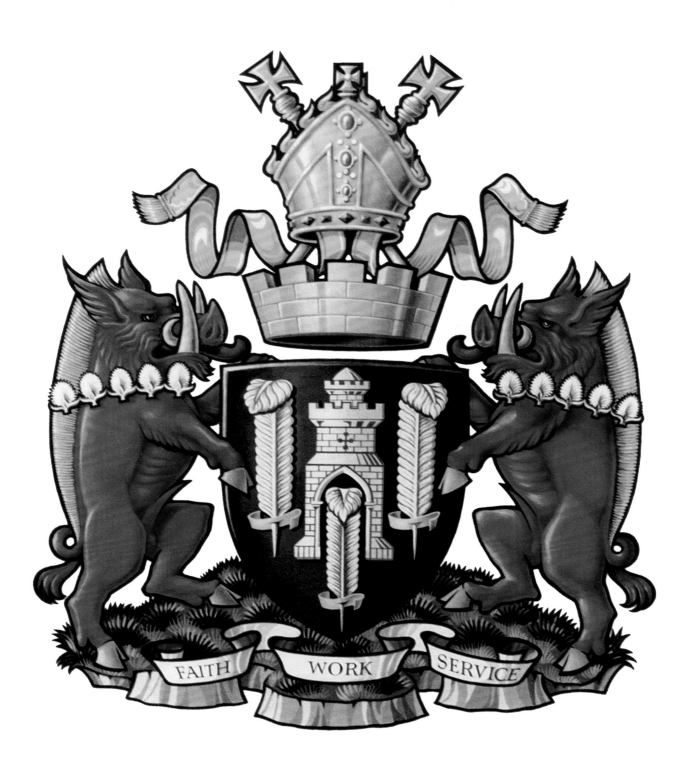

FAITH WORK SERVICE

CALNE

The arms and badge banner of Stephen Slater, FHS, record his life-long interest in armory and local history. Painted in 1993, the arms are a good example of how personal information may be interpreted heraldically and recorded for posterity.

The gold and black tinctures are from the arms of the Dowdeswell family of Pull Court, Worcestershire, long-time owners of the mansion which became Stephen Slater's school and where a set of stained glass windows inspired his interest in heraldry. The black wings represent the rooks of Salisbury Plain where Stephen Slater lives and the cross-crosslets the hundreds of Wiltshire churches he has recorded. The sickles in the crest and the green and red liveries in the badge banner are taken from the heraldry of the Hungerford family, the principal landowners on Salisbury Plain in the fifteenth century. At the time of the grant, Stephen Slater lived in the parish of Maddington much of which had been owned by the nuns of nearby Amesbury Abbey. The Maunche Ermine (a symbol of purity) represents the Abbey which at the Dissolution was purchased by the Tooker family whose arms bore three hearts ('tout coeur') one of which appears in Stephen Slater's badge as depicted on the badge banner.

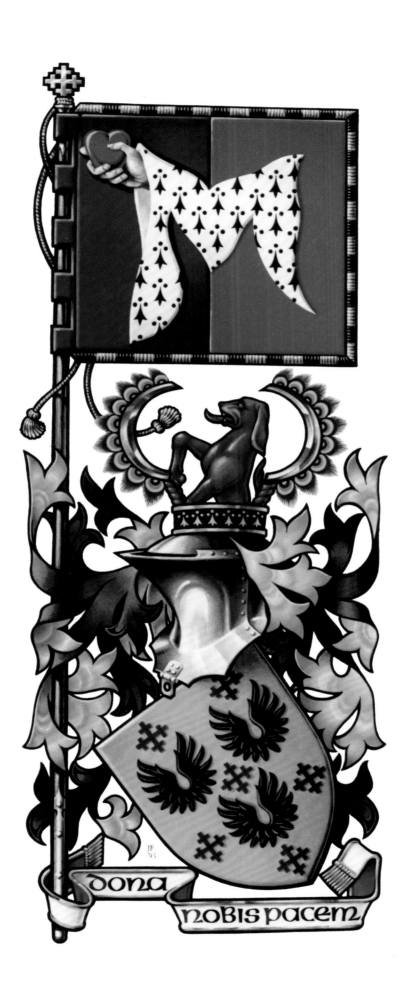

dona nobis pacem

A library painting of the arms of the Reverend Travis Talmadge du Priest, Jr, BA, PH.D, MTS, in gouache colour, originally on hand-made paper.

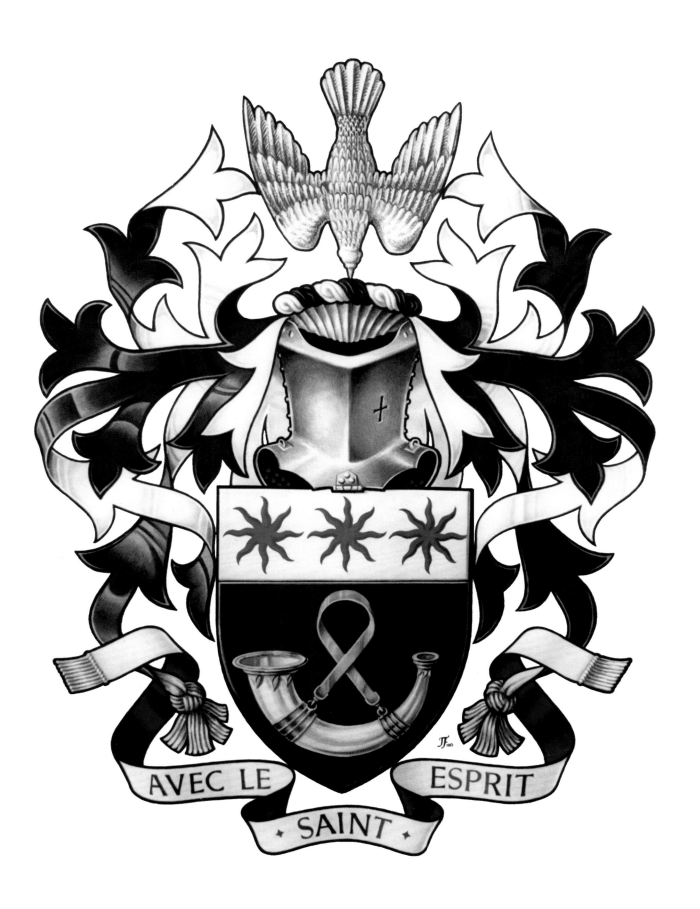

AVEC LE ESPRIT

SAINT

The armorial bearings of Sir Alfred William Meeks, KBE (1849–1932), of New South Wales, Australia. A merchant and politician, Sir Alfred Meeks was born on 15 April 1849 in Cheltenham, Gloucestershire, England. He was the son of William Meeks, shoemaker, and his wife Maria, *née* Healing. The family migrated to Melbourne in 1854. The painting is in gouache colour on artboard, *c.* 1963.

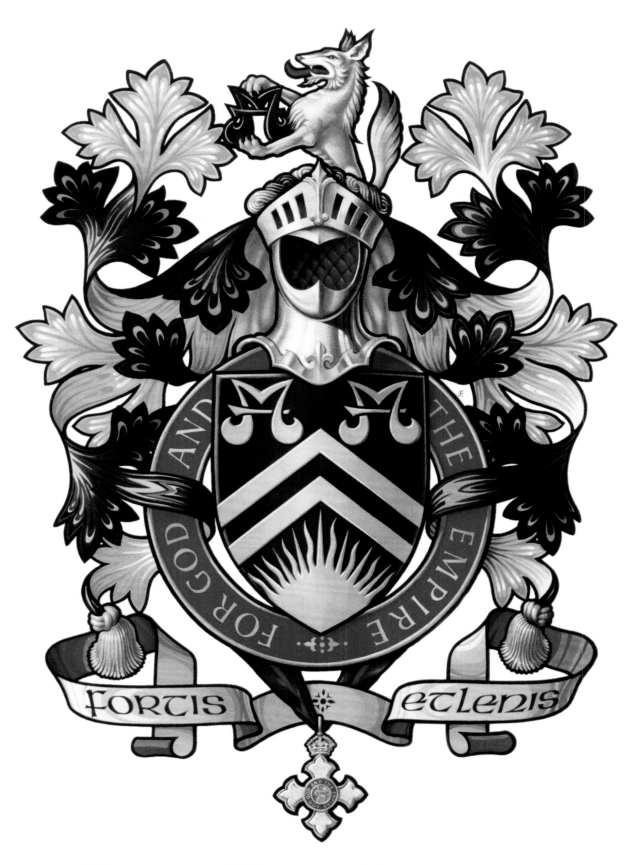

Hon. sir alfred william meeks

Display panels prepared for a local history exhibition in 2011 depicting (*above*) the arms of Sir John Hinton, physician to Charles I and Charles II, and (*below*) the arms of Stephen Smith Burt, MD, Professor of Medicine and Physical Diagnosis.

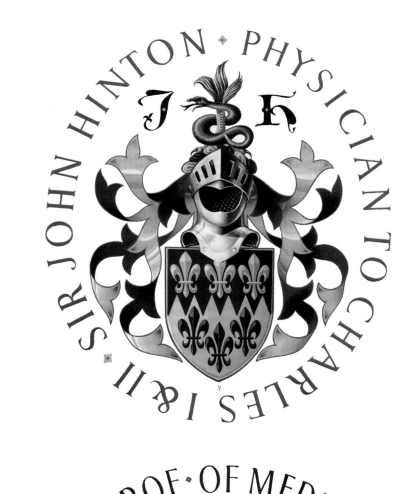

SIR JOHN HINTON · PHYSICIAN TO CHARLES I & II ·

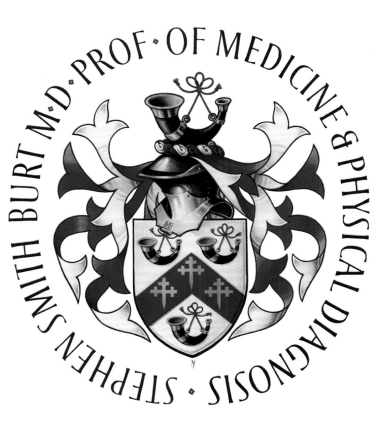

STEPHEN SMITH BURT M·D· PROF · OF MEDICINE & PHYSICAL DIAGNOSIS ·

A library painting in gouache of the armorial bearings of Elmer Calvin Roberts of Brownstown, Jackson County, Indiana, USA. 1998.

GRACIA SEAMUS

Four panels depicting the arms of early settlers from Great Britain who became significant members of the early American community. These examples are interpretations of blazons given in the 1903 edition of *John Matthews' American Armoury and Blue Book*. The blazons given by Matthews are incomplete and further research was required before work could begin. The series was begun in 2009 and finally completed in 2012.

GEORGE CLARKE ESQ.
OF SWANSWICK ENG.
COLONIAL GOVERNOR
OF NEW YORK 1737-44

Wm. CHESEBROUGH
✠ EMIGRATED FROM
ENGLAND TO BOSTON
MASSACHUSETTS 1630

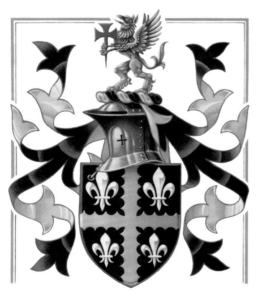

JAMES BANKS ESQUIRE
FROM YORKSHIRE ENG.
SETTLED IN NEWARK
NEW JERSEY circa 1729

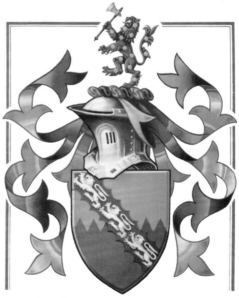

THOMAS EMERSON Esq.
OF LINCOLNSHIRE ENG.
SETTLED IN IPSWICH
MASSACHUSETTS 1650

The arms and banner of the Revd James Alfred Ross, granted in 1882. Painted in 2005, this is one of a set of Scottish armorial illustrations for a treatise on Scottish heraldry.

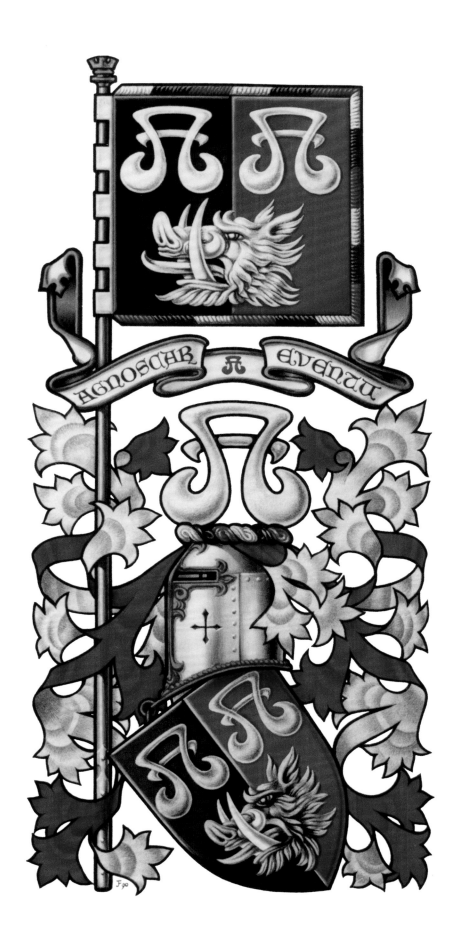

AGNOSCAR A EVENTU

The armorial bearings of James Pettigrew Esq. are an example of the simplicity and clarity of heraldic design which contain many half hidden key references to his professional and private life. James Pettigrew writes: 'I was a foster child at a school founded by one William Palmer in 1706. The school stabilised my life and gave me a set of values that have served me throughout the years. I wished to commemorate the school when I was granted arms and chose a Palmer's Staff from the arms of William Palmer: Argent a Lion rampant between three Palmer's Staffs Sable tipped knobbed and handled Or'. Library painting in gouache on vellum-finished paper.

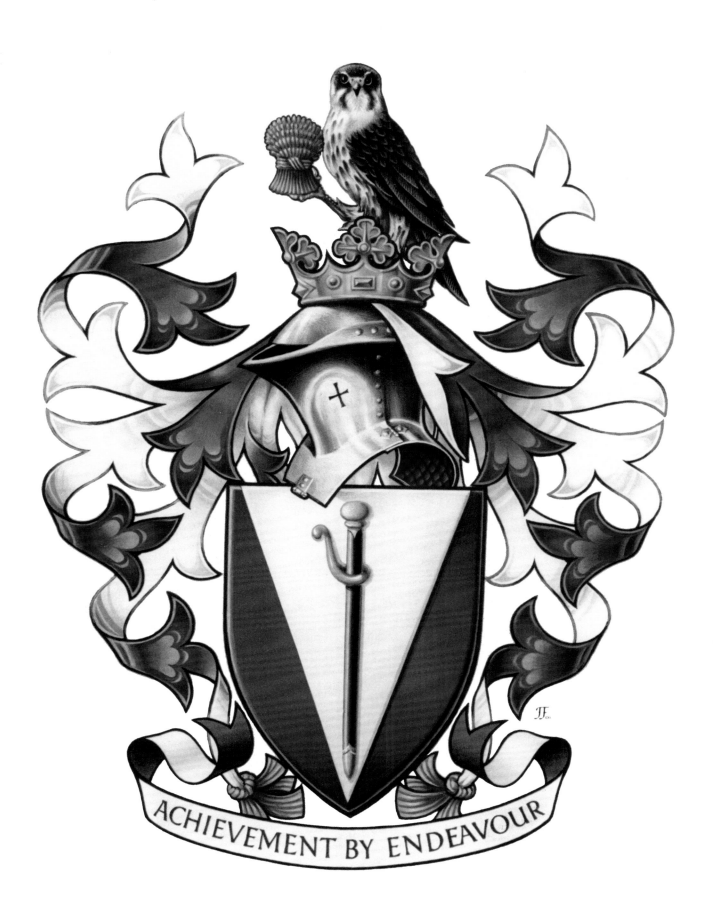

ACHIEVEMENT BY ENDEAVOUR

Municipal heraldry: the arms of Flintshire County Council granted in 1938. Gouache colour on artboard.

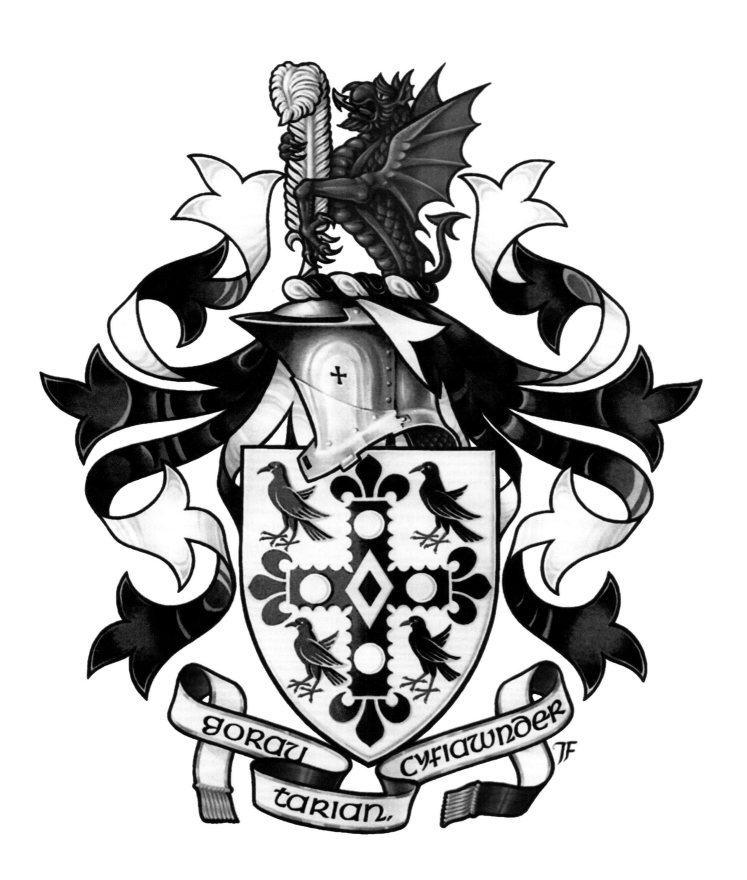

GORAU CYFIAWNDER TARIAN

Corporate heraldry: the striking armorial bearings of the Royal Photographic Society. Exhibition panel, c. 1985.

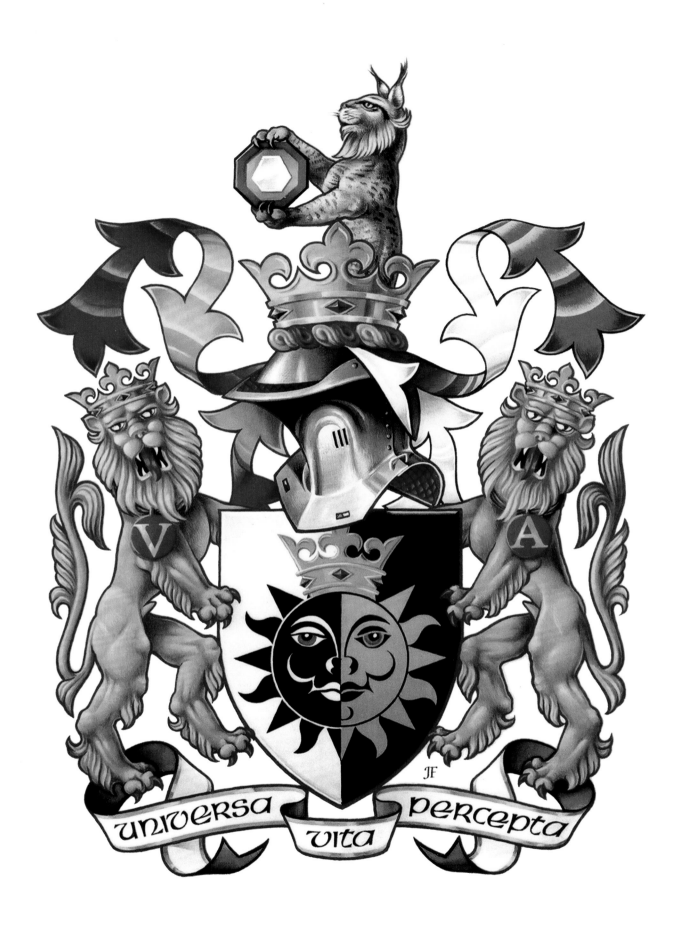

UNIVERSA VITA PERCEPTA

An heraldic roundel of the arms of Martin Davies Esq. together with the armiger's badge beneath. The Welsh motto means 'From a good heart, good will come'. Gouache colour on vellum-finished paper.

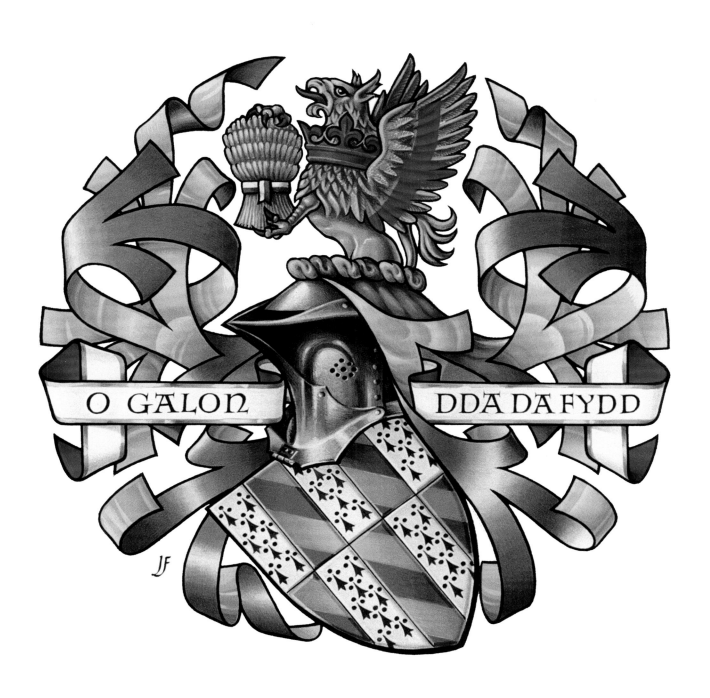

O GALON DDA DA FYDD

The arms and badge of the Revd Dr William Beaver. When granted in 2005 the armiger was dissatisfied with the blazon and the official library painting. He had requested that the clouds and rays be depicted in a circle behind the cross Moline so that it represented, in effect, glory bursting from a crown of thorns. When commissioned to depict the arms, John Ferguson rose to the challenge in this painting, to the delight of William Beaver and his family, who particularly liked the iridescent blue demi-beaver in the crest. John admits that this was great fun to do – it gave him an opportunity to render the strong skeletal and muscular attributes of the animal showing through its wet glistening fur.

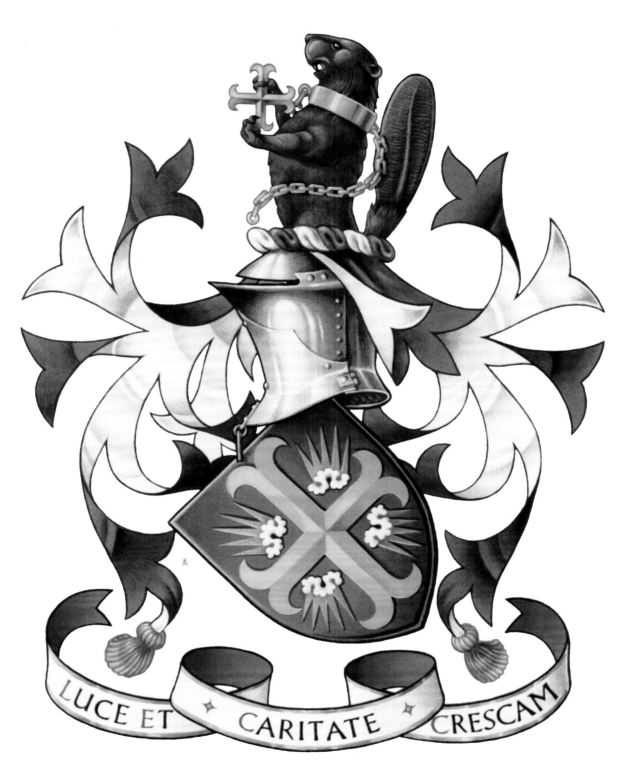

LUCE ET CARITATE CRESCAM

ACKNOWLEDGEMENTS

John Ferguson and Stephen Friar hereby acknowledge with gratitude The Revd. Dr. William Beaver who first proposed a book dedicated to John Ferguson's work, and Peter Clifford and his colleagues at Boydell and Brewer who have produced a book worthy of its subject.

We also acknowledge the support of The Society of Heraldic Arts and the generosity of The Heraldry Society who have underwritten the project.

Illustrations on pages 15, 27 and 51 are taken from *Basic Heraldry* by Stephen Friar and John Ferguson, published in 1993 by The Herbert Press and used by permission of Bloomsbury Publishing Plc.